STAMPABILITY

✤HERALDIC✤

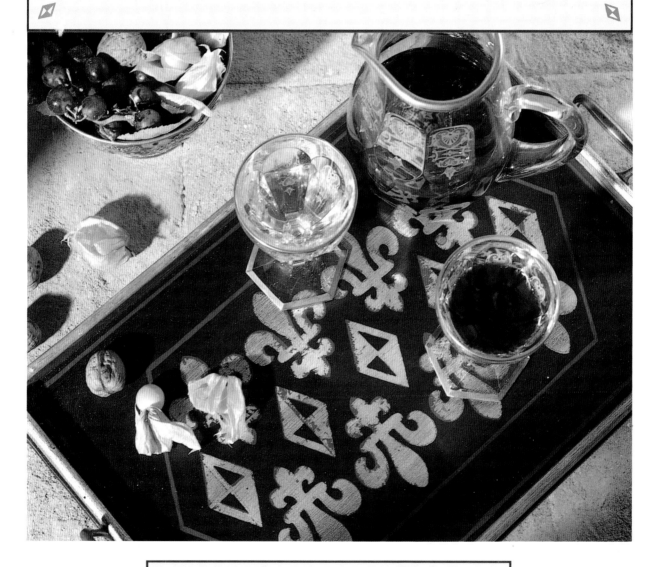

STEWART & SALLY WALTON
PHOTOGRAPHY BY GRAHAM RAE

LORENZ BOOKS
NEW YORK • LONDON • SYDNEY • BATH

CONTENTS

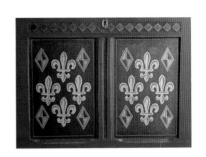

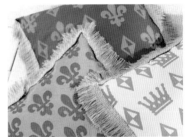
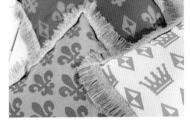

SURFACE APPLICATIONS

The surface onto which you stamp your design will greatly influence the finished effect.
Below are just some of the effects which can be achieved.

STAMPING ON ROUGH PLASTER

You can roughen your walls before stamping by mixing spackle to a fairly loose consistency and spreading it on the wall. When it has dried, roughen it with coarse sandpaper, using random strokes.

STAMPING ON SMOOTH PLASTER OR PAPER

Ink the stamp with a small foam rubber roller for the crispest print. You can create perfect repeats by re-inking with every print, whereas making several prints between inkings varies the strength of the prints and is more in keeping with hand-printing.

STAMPING ON WOOD

Sand down any type of wood to give the paint a better surface to adhere to. Some woods are very porous and absorb paint, but you can intensify the color on these by overprinting later. Wood looks best lightly stamped so that the grain shows through. Seal your design with clear matte varnish.

STAMPING ON GLASS

Wash glass in hot water and detergent to remove any dirt or grease, and dry thoroughly. It is best to stamp on glass that does not come in contact with food, such as vases or windows. Ink the stamp with a foam rubber roller and practice on a spare sheet of glass. As glass has a slippery, non-porous surface, you need to apply the stamp with a direct on/off movement. Each print will have a slightly different character, and the glass allows the pattern to be viewed from all sides.

STAMPING ON TILES

Wash and dry glazed tiles thoroughly before stamping. If the tiles are already on the wall, avoid stamping in areas which require a lot of cleaning, as the paint will only withstand an occasional gentle wipe with a damp cloth. Once stamped, loose tiles can be baked to add strength and permanence to the paint. Read the paint manufacturer's instructions (and disclaimers!) before you do this. Ink the stamp with a small foam rubber roller and apply with a direct on/off movement.

STAMPING ON FABRIC

As a rule, natural fabrics are the most absorbent, but to predict the final stamped effect, experiment on a small sample. Fabric paints come in a variety of colors, but to obtain subtle shades, you may need to combine primary colors with black and white. Always place a sheet of cardboard behind the fabric to protect your work surface. Apply the paint with a foam rubber roller, brush or by dipping. You will need more paint than for a wall, as fabric is more absorbent.

PAINT EFFECTS

Once you have mastered the basics of stamp decorating, there are other techniques you can use to enrich the patterns and add variety. Stamped patterns can be glazed over or overprinted to inject subtle or dramatic character changes.

STAMPING LATEX PAINT ON PLASTER, DISTRESSED WITH TINTED VARNISH

The stamped pattern will already have picked up the irregularities of the wall surface and, if you re-ink after several prints, some prints will look more faded than others. To give the appearance of old hand-blocked wallpaper, paint over the whole surface with a ready-mixed antiquing varnish. You can also add color to a varnish, but never mix a water-based product with an oil-based one.

STAMPING LATEX PAINT ON PLASTER, COLORED WITH TINTED VARNISH

If the stamped prints have dried to a brighter or duller shade than you had hoped for, you can apply a coat of colored varnish to modify the tone. It is possible to buy ready-mixed color-tinted varnish, or you can add color to a clear varnish base. A blue tint changes red into purple, a red changes yellow into orange, and so on. The color changes are gentle because the background changes at the same time.

STAMPING WITH WALLPAPER PASTE, WHITE GLUE AND WATERCOLOR PAINT

Mix three parts pre-mixed wallpaper paste with one part white glue and add watercolors. These come ready-mixed in bottles with internal droppers. The colors are intense, so you may only need a few drops. The combination gives a sticky substance which the stamp picks up well and which clings to the wall without drips. The white glue dries clear to give a bright, glazed finish.

STAMPING WITH A MIXTURE OF WALLPAPER PASTE AND LATEX PAINT

Mix up some wallpaper paste and add one part to two parts latex paint. This mixture makes a thicker print that is less opaque than the usual latex paint version. It also leaves a glazed surface that picks up the light.

STAMPING LATEX PAINT ON PLASTER, WITH A SHADOW EFFECT

Applying even pressure gives a flat print. By pressing down more firmly on one side of the stamp than on the other, you can create a shadow effect on one edge. This is most effective if you repeat the procedure, placing the emphasis on the same side each time.

STAMPING A DROPPED SHADOW EFFECT

To make a pattern appear three-dimensional, stamp each pattern twice. Make the first print in a dark color that shows up well against a mid-tone background. For the second print, move the stamp slightly to one side and use a lighter color.

DESIGNING WITH STAMPS

To design an effective pattern with stamps, you need to find a compromise between printing totally at random and measuring precisely with a machine-like regularity. To perfect your design skills, practice your pattern on strips of paper or squares of cardboard. Try a sample patch with a stamp pad on scrap paper to plan your design, but always wash and dry the stamp carefully before proceeding to the main event.

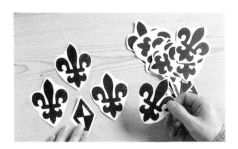

USING PAPER CUT-OUTS
The easiest way to plan your design is to stamp and cut out as many pattern elements as you need and use them to mark the position of your finished stamped prints.

CREATING A REPEAT PATTERN
Use a strip of paper as a measuring device for repeat patterns. Cut the strip the length of one row of the pattern. Use the stamp block to mark where each print will go, with equal spaces in between. You can also use a vertical strip. Position the horizontal strip against it as you print.

USING A PAPER SPACING DEVICE
This method is very simple. Decide on the distance between prints, and cut a strip of paper to that size. Each time you stamp, place the strip against the edge of the previous print and line up the edge of the block with the other side of the strip. Use a longer strip to measure the total distance required.

CREATING AN IRREGULAR PATTERN
If your design is irregular, plan the pattern first on paper. Cut out paper shapes the size of the spaces between motifs and use these to position the stamp. Or, use a cardboard spacing device to raise the stamp above the previous print.

COMPILING A LARGER MOTIF
Use the stamps in groups to make up a larger design. Try stamping four together in a block, or overlapping an edge so that only a section of the stamp is shown. Use the stamps upside down, back to back and rotated in different ways. Experiment on scrap paper first.

USING A PLUMBLINE
Attach a plumbline at ceiling height to hang down the wall. Hold a cardboard square behind the plumbline so that the string cuts through two opposite corners. Mark all four points, then move the cardboard square down. Continue in this way to make a grid for stamping a regular pattern.

MEDIEVAL HALLWAY

Decorate your hallway using medieval patterns and colors that will make every entrance a dramatic one for you and your visitors. Hallways often seem dark and narrow but can be lightened and brightened using two colors of paint. A dark color above chair rail height creates the illusion of a lower ceiling, while a light color below, combined with a light floor covering, seems to push the walls outward to give the illusion of width. The crown pattern is then stamped on the walls in a diagonal grid that is easy to draw using a plumbline and a square of cardboard.

YOU WILL NEED
pencil
latex paint in dark blue-green, buttermilk
yellow and light cream
paintbrush
fine sandpaper
masking tape
ruler
paint roller
wallpaper paste (mixed according to the
manufacturer's instructions)
plate
foam rubber roller
diamond and crown stamps
plumbline
square of cardboard

1 Draw a horizontal pencil line on the wall, at chair rail height. Paint the top half blue-green and the bottom buttermilk yellow. When dry, lightly sand the blue-green paint. Adhere a strip of masking tape along the lower edge of the blue-green, and another 4 inches below. Apply light cream with a dry roller over the yellow.

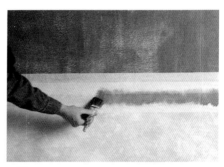

2 Stick another length of masking tape 5 inches below the one marking the edge of the green section. Using a paintbrush and blue-green paint, fill in the stripe between the two lower strips of tape. Leave to dry and then peel off the tape. Lightly sand the blue-green stripe so it matches the upper section of the wall.

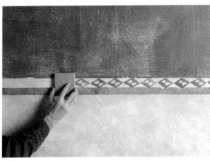

3 On a plate, mix one part blue-green paint with two parts pre-mixed wallpaper paste and stir well. Ink the diamond stamp with the foam rubber roller and stamp a row of diamonds on the narrow cream stripe.

4 Use a plumbline and a square of cardboard to mark an all-over grid on the cream half of the wall. This will be used as a guide for the crown stamps.

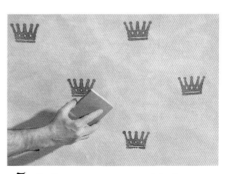

5 Ink the crown stamp with the blue-green paint and wallpaper paste mixture and stamp a motif on each pencil mark. Make several prints before re-inking to create variation in the density of the prints.

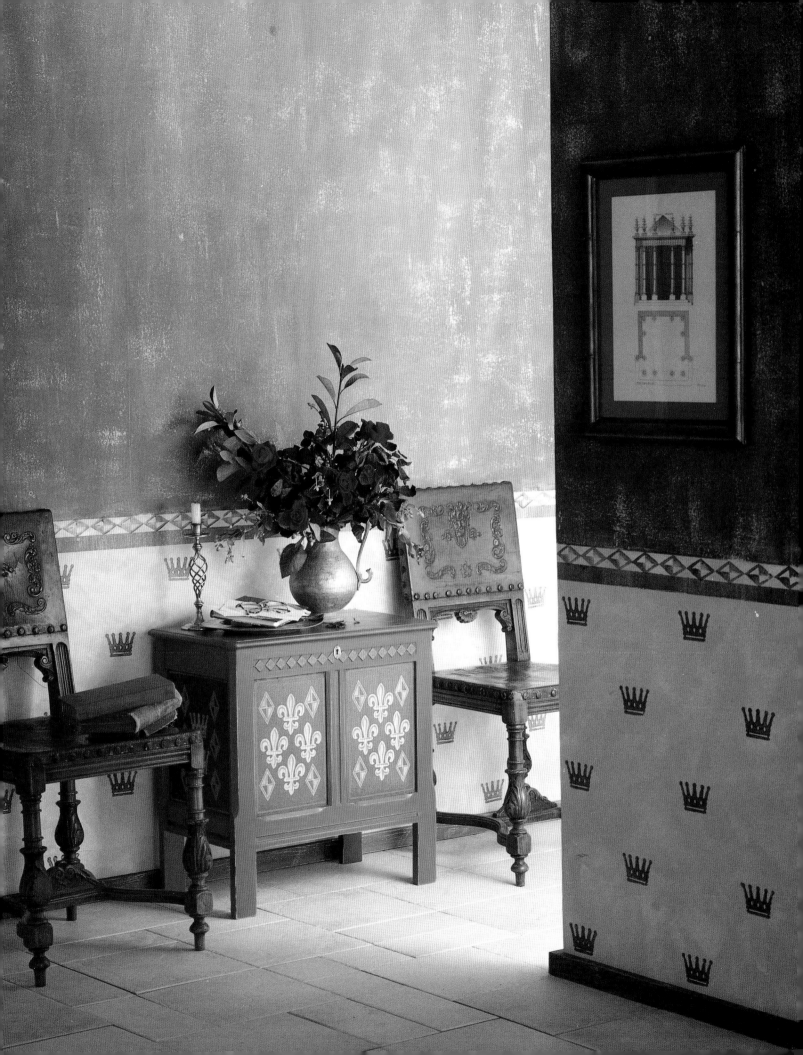

GOTHIC CUPBOARD

Visit junk shops to find old pieces of furniture with interesting detailing and panels that are large enough to be stamped with a heraldic design. This small bedside cupboard looked very gloomy with its original dark surface, but refinished and stamped, it has become the unique centerpiece of the medieval entrance hall.

YOU WILL NEED
small wooden cupboard
fine sandpaper
emulsion paint in rust-brown, dark blue-green, lilac and yellow-ocher
paintbrush
medium-sized artist's paintbrush
black stamp pad
diamond and fleur-de-lys stamps
scrap paper
scissors
pencil
ruler (optional)
plates
foam rubber rollers
red-orange, smooth-flowing water-based paint (thinned latex paint, poster paint or ready-mixed watercolor)
lining brush
shellac and brush
water-based tinted varnish
fine steel wool

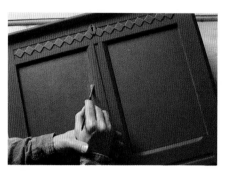

1 Sand away the old varnish or paint. Paint the main body of the cupboard rust-brown and the panels and any carved details blue-green. Use the artist's brush to paint the blue-green right into the panel edges to ensure even coverage.

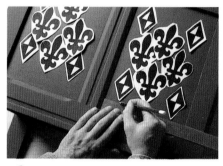

2 Use the stamp pad to print the diamond and fleur-de-lys motifs on paper and cut them out. Lay them on the panels to plan your pattern. Make a small pencil mark on the panel at the base point of each motif to use as a guide for stamping. Use a ruler if necessary to make sure the design is symmetrical. Mark the base point of the motif on the back of each stamp block so that you can line up the marks when you print.

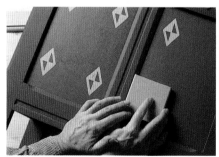

3 Spread some lilac paint onto a plate and run the roller through it until it is evenly coated. Ink the diamond stamp and print diamonds using the pencil marks as a guide.

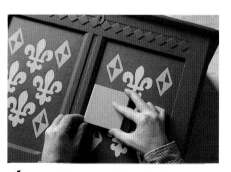

4 Spread some yellow-ocher paint onto a plate and ink the fleur-de-lys stamp. Print the fleur-de-lys designs, using the pencil marks as a guide.

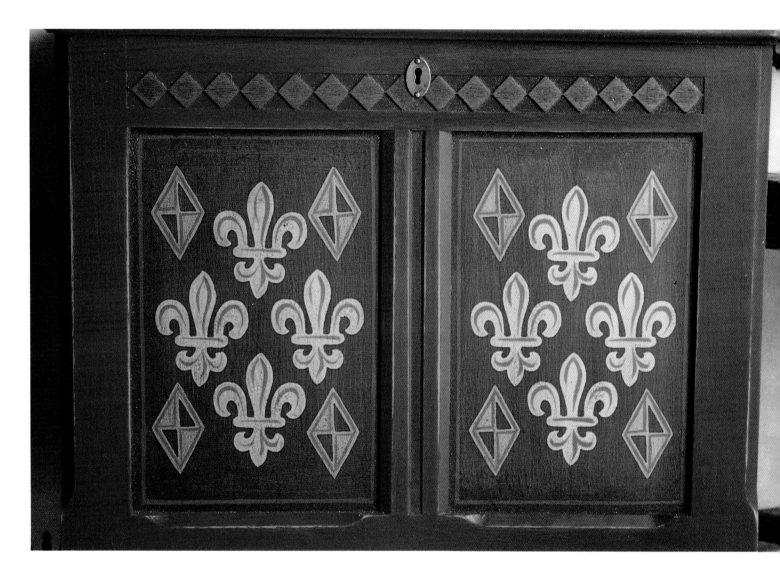

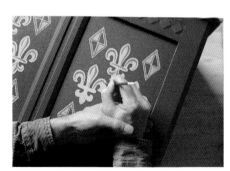

5 Using red-orange paint and the lining brush, add hand-painted details to the motifs. Support your painting hand with your spare hand resting on the surface of the cupboard, and aim to get a smooth, continuous line.

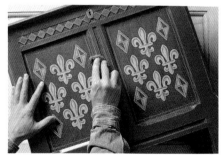

6 Apply a coat of shellac to seal the surface for varnishing and allow it to dry. Apply a fairly thick coat of tinted varnish and allow it to dry. Rub the raised areas and edges of the cupboard with fine steel wool to simulate natural wear and tear.

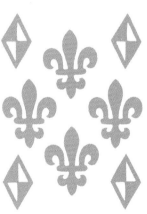

DIAMOND LAMPSHADE

Lampshades can be used to link patterns used on borders, walls and fabrics and can help to coordinate a room. This deep burgundy shade is enhanced with a stamped diamond pattern around the middle and a thin golden band around the top and bottom.

YOU WILL NEED
burgundy lampshade
gold paint
medium-sized artist's paintbrush
black stamp pad
diamond stamp
scrap paper
scissors
pencil
thin cardboard
plate
foam roller

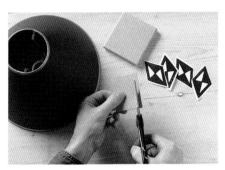

1 Paint a narrow golden band around the top and bottom edges of the lampshade. Use the stamp pad to print eight diamond motifs on paper and cut them out.

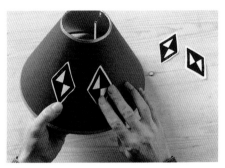

2 Arrange the shapes around the lampshade to plan your design and judge the spacing between the motifs. Mark the base point of each motif on the lampshade in pencil.

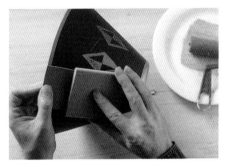

3 Cut a strip of thin cardboard as a guide for printing. Spread some gold paint onto a plate and run the roller through it until it is evenly coated. Ink the stamp to print a row of diamonds around the lampshade. Line up the cardboard strip with the bottom rim of the lamp and stamp just above it to ensure that each print is the same distance from the gold border.

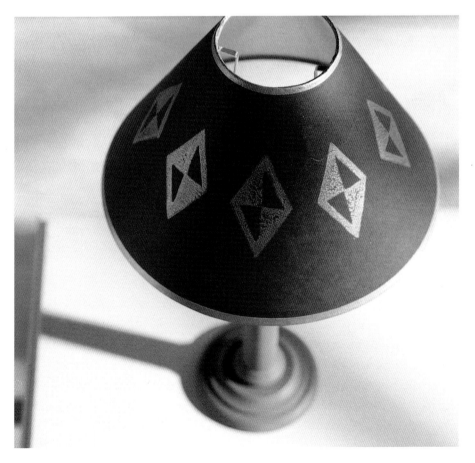

CANDLE BOX

A long time ago, every home would have had a candle box hanging on the kitchen wall to meet the lighting needs of the household. Although rarely needed in quite the same way today, candle boxes are attractive and nostalgic design features, and add to an inviting atmosphere. Candle boxes can be bought, but are quite easy to make from five pieces of wood. The open top allows you to see when your supply is running low and the sight of the new candles is somehow reassuring.

YOU WILL NEED
wooden candle box
fine sandpaper
shellac and brush
plate
dark oak wood stain
foam rubber roller
diamond, crown and fleur-de-lys stamps
lining brush

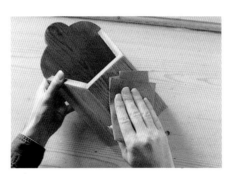

1 Sand away any varnish and smooth any rough edges on the box.

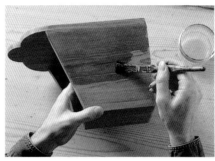

2 Paint the bare wood with a single coat of shellac.

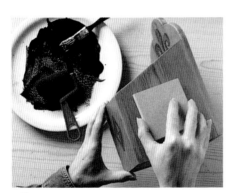

3 Spread some wood stain onto a plate and run the roller through it until it is evenly coated. Ink the stamps and print a single motif on each side of the box. Print the fleur-de-lys so it will be visible above the candles. Use the lining brush to paint a thin border on all sides.

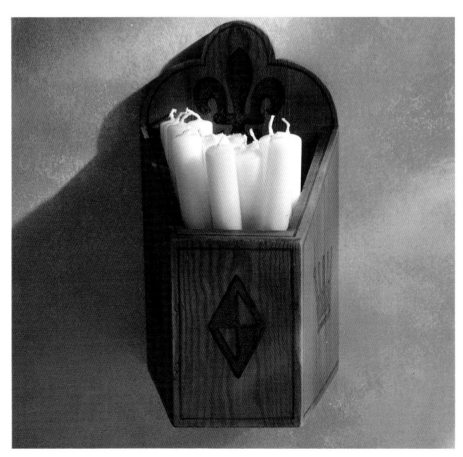

FLEUR-DE-LYS PILLOWS

A new set of pillows can instantly revive a tired decor or add a distinctive touch to a furnished apartment. If you are personalizing your home with pillows, why not do it with vibrant color contrasts for maximum impact? Choose hard-wearing medium-weight cotton pillow covers. Wash and iron the covers before decorating them, and set the fabric paint after stamping with a hot iron, according to the manufacturer's instructions. This pattern is European in origin, but the hemp fringing gives the pillows a tropical flavor.

YOU WILL NEED

fleur-de-lys, crown and diamond stamps
black stamp pad
scrap paper
scissors
three brightly colored plain cotton pillow
covers
thin cardboard
pencil
fabric paint in blue, orange and
bright pink
plate
foam rubber roller
long ruler
iron
hemp fringing, approximately 6yd
needle and thread or fabric glue
three pillows

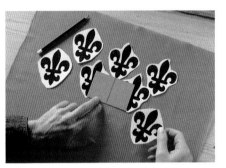

1 Print some fleurs-de-lys on paper and cut them out. Place a pillow cover on a flat surface and arrange the motifs. Here, the bases of the motifs are 4 inches apart. Cut the cardboard to the width of the space between the bases and about 3 inches high. Draw a line down the center of the cardboard.

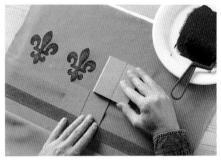

2 Ink the stamp with blue paint. Place a ruler across the fabric and rest the cardboard on it. Print the first motif above it. Move the cardboard so that its top left corner rests on the base of the first motif. Line up the center of the stamp with the right edge of the cardboard to print the next motif.

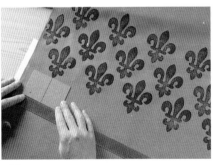

3 Continue using the cardboard to print the first row. Move the ruler down for each new row, keeping it at a right angle to the edge of the cushion pillow.

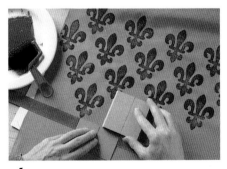

4 Print alternate rows so that the motifs fill the spaces left between the motifs in the row above. Print the other pillow covers using the same technique. Set the fabric paint with a hot iron. Attach hemp fringing around the covers and insert the pillows.

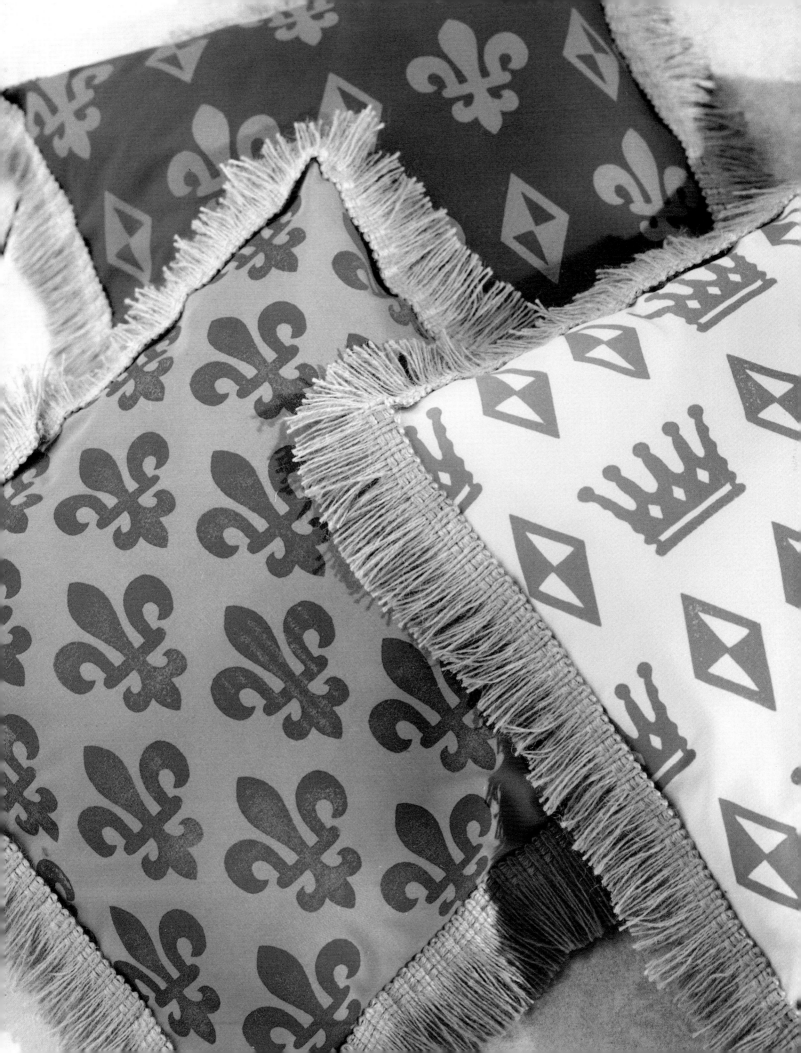

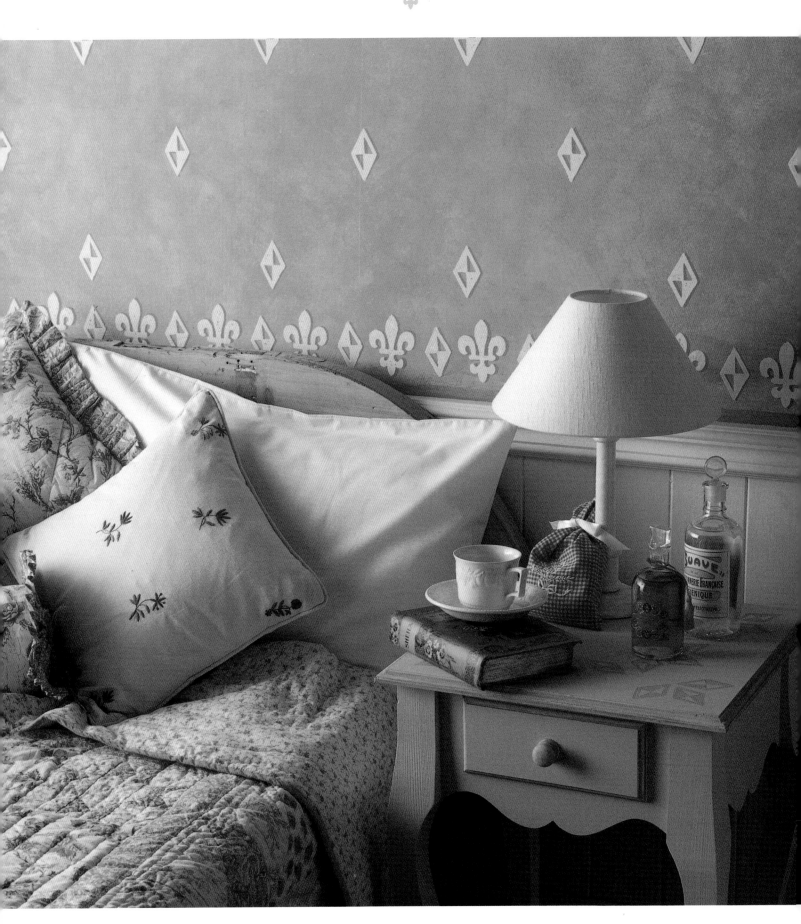

COUNTRY GRANDEUR BEDROOM

Redecorating a bedroom can be as refreshing as taking a vacation, and stamping is such fun that it won't seem like work at all. First sponge over a cream background with terracotta latex paint and add a final highlight of pink to create a warm, mottled color. Any plain light-colored wall can be covered in this way. Two of the stamps are then combined to make a border which coordinates with an all-over pattern on the wall and a bedside table. You could also decorate matching curtains and cushions, or stamp the border on sheets and pillowcases.

YOU WILL NEED
latex paint in dark salmon-pink, off-white
and dusky pink
plates
foam rubber rollers
fleur-de-lys and diamond stamps
thin cardboard
scissors
plumbline
pencil
long ruler
small table, painted off-white
pair of compasses
black stamp pad
scrap paper
paintbrush
clear matte varnish and brush

1 Spread some dark salmon-pink latex paint onto a plate and use the roller to ink the fleur-de-lys stamp. Stamp a row of fleurs-de-lys above the chair rail using a piece of cardboard 3 inches wide to space the motifs.

2 Ink the diamond stamp with the dark salmon-pink paint, and print diamonds between the fleurs-de-lys. Use a cardboard spacing device if you are nervous about judging the positioning by eye.

3 Cut a cardboard square about 10 x 10 inches. Attach a plumbline at ceiling height, just in from one corner so that the weighted end hangs down to the border. Use to mark a grid for the diamond stamps.

4 Ink the diamond stamp with the salmon-pink paint and print a diamond on every pencil mark to make an all-over pattern.

5 Spread some off-white latex paint onto a plate and run the roller through it until it is evenly coated. Ink both stamps and overprint the border pattern. To create a dropped shadow effect, stamp each print slightly below and to the left of the motif that has already been printed.

6 Overprint the wall pattern in the same way.

7 Lay the ruler across the table top from corner to corner in both directions to find the central point. Mark the center lightly in pencil.

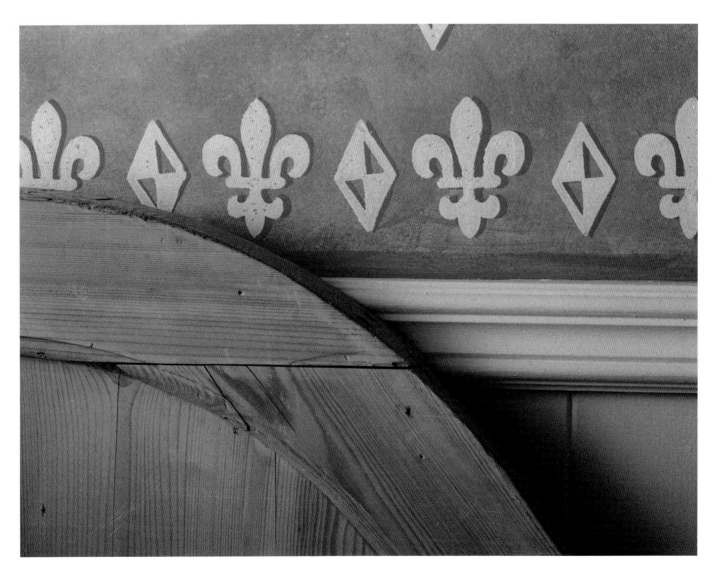

8 Set the compass to a radius of 4 inches and lightly draw a circle in the center of the table top.

9 Increase the radius to 4¾ inches. Position the point of the compass on the edge of the circle, in line with the middle of the back edge of the table. Mark the point on the circle at the other end of the compass, then move the point of the compass to this mark. Continue around the circle to make five divisions. Connect the marks with light pencil lines to make a pentagonal shape.

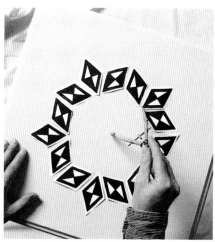

10 Use the stamp pad to print fifteen diamonds on paper and cut them out. Arrange them around the pentagon, as shown. Use the compass to mark the inner points of the five inward-pointing diamonds.

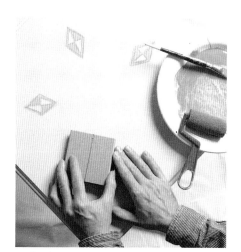

11 Spread some dusky pink latex paint onto a plate and run the roller through it until it is evenly coated. Ink the stamp and print the five inward-pointing diamonds at the marked positions.

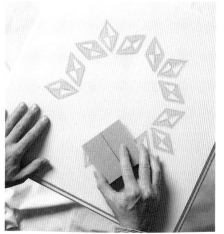

12 Re-ink the stamp as necessary and print the rest of the medallion pattern. Print an arrangement of three diamonds in each corner of the table top. Paint any molding of the table in the same shade of pink. Seal the table with a coat of clear matte varnish.

GOTHIC PLATE

Large china display plates look great on the wall and they don't have to be confined to country kitchen-type interiors, as demonstrated by this bold pattern. The plate used here is a large platter with a pale blue border outlined in navy blue, although the design can also be stamped on a plain plate. Use acrylic enamel paint on ceramics and glassware. It can be baked in a household oven according to the manufacturer's instructions. The resulting patterns are very hard-wearing and even seem to stand up to dishwashers and scouring pads, but the paints are recommended for display rather than food use.

YOU WILL NEED
black stamp pad
diamond and crown stamps
scrap paper
scissors
dinner plate
acrylic enamel paint in navy blue and
deep orange
plates
foam rubber rollers
ruler

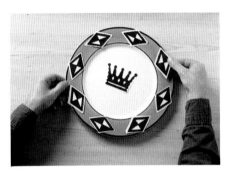

1 Use the stamp pad to print eight diamond motifs and one crown on paper and cut them out. Arrange them on the plate to design the border pattern and central motif.

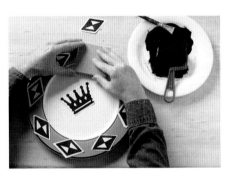

2 Spread some navy blue acrylic enamel paint onto a plate and run the roller through it until it is evenly coated. Ink the diamond stamp, then remove one of the paper shapes and stamp a diamond in its place.

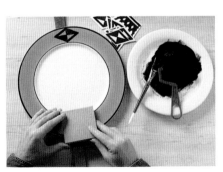

3 Place a ruler under the plate, so that it runs centrally from the printed motif to the one opposite. Line up the stamp with the edge of the ruler to print the second motif. Print the motifs on the other two sides in the same way, then fill in the diamonds in between, judging by eye.

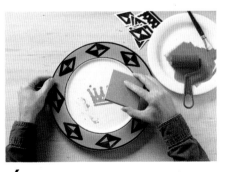

4 Ink the crown stamp with deep orange paint and stamp a single crown in the center of the plate. Bake the plate in the oven, according to the manufacturer's instructions.

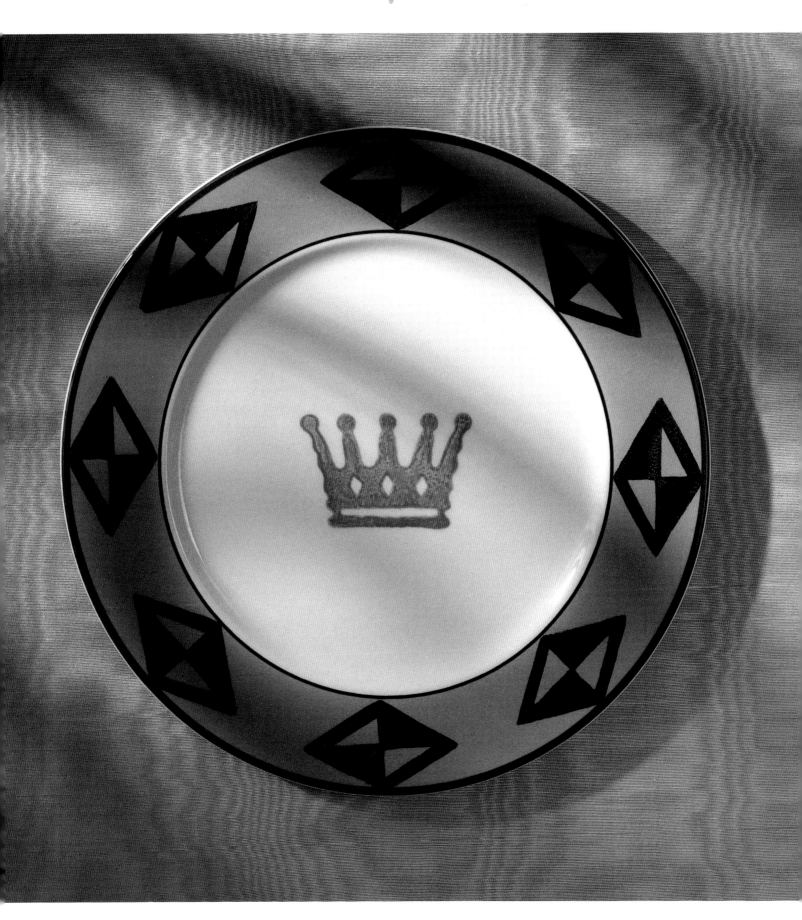

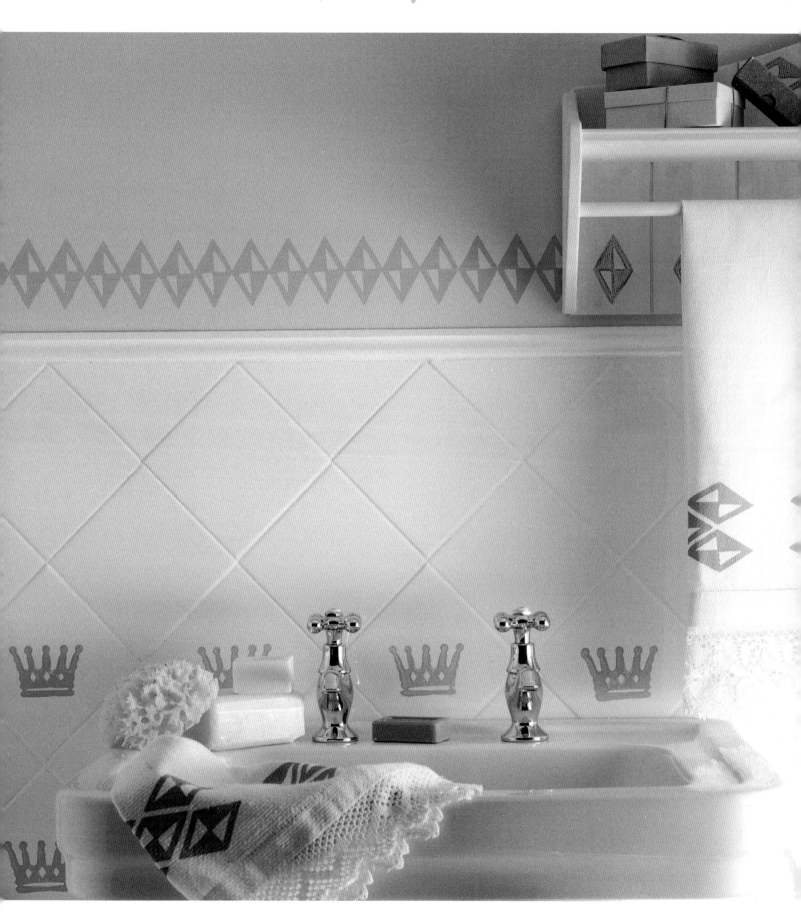

REGAL BATHROOM

Decorating a bathroom on a budget usually means that all your money goes on the bathroom suite, flooring and faucets. A pure white bathroom may look clean and fresh, but a certain amount of warmth in pattern and color is needed to prevent it from seeming too clinical. Stamping enables you to achieve a coordinated finish on tiles, fabric and furniture at little extra cost. If you stamp a set of tiles using acrylic enamel paint before fixing them to the wall, the design can be baked in the oven for a very hard-wearing finish. If the tiles are already in place, you can use the same paint but it won't stand up to abrasive cleaning, so use it away from sinks and bath tubs.

YOU WILL NEED
masking tape
diamond and crown stamps
pencil
latex paint in gray and yellow-ocher
plates
foam rubber rollers
wooden shelf with rail
white glue
clear matte varnish and brush
black stamp pad
scrap paper
scissors
white cotton piqué handtowels
gray fabric paint
iron
plain white tiles
clean cloth
gray acrylic enamel paint

1 Adhere a length of masking tape along the top edge of the molding above the tiles or along the top of the tiles themselves if there is no molding. This will give you a straight line to stamp along. Mark the position of the actual stamp in pencil. on the edge of the stamp block.

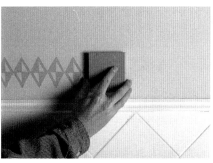

2 Spread some gray latex paint onto a plate and run the roller through it until it is evenly coated. Ink the stamp and print the diamond border. Line up the pencil mark on the stamp block with the edge of the previous print so that the diamonds meet without overlapping.

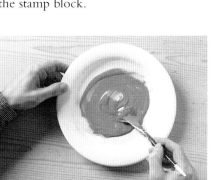

3 To decorate the shelf, mix two parts yellow-ocher latex paint with one part white glue. The glue will make the paint stickier and will dry to give a bright, glazed finish.

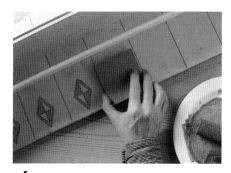

4 Run the roller through the paint until it is evenly coated and ink the diamond stamp. The design of the pattern will depend on the shelf. Here, a diamond is printed on each plank to make evenly spaced rows.

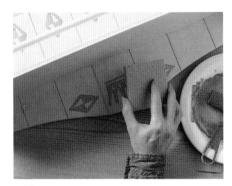

5 Stamp a crown in the center at the top of the shelf and add a diamond on either side.

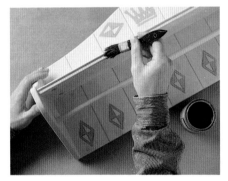

6 Seal the shelf with at least one coat of clear matte varnish.

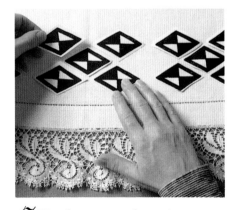

7 Use the stamp pad to print twenty diamond motifs on paper and cut them out. Arrange them in three rows across the width of a towel, adjusting the spacing until you are happy with it.

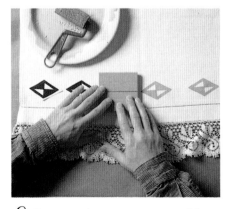

8 Remove the top two rows of the pattern, leaving only the bottom row in place. Spread some gray fabric paint onto a plate and run the roller through it until it is evenly coated. Ink the stamp, and remove each paper diamond individually as you replace it with a stamped print.

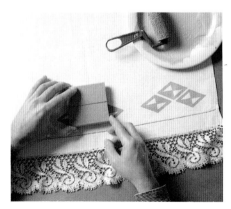

9 Stamp the next row of the pattern with a diamond between each pair on the row below. Draw a line down the center of the back of the stamp block. Line it up with the top of the first row to help you position the second row.

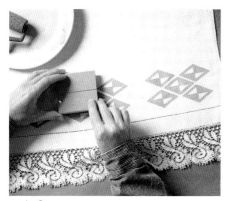

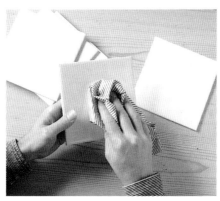

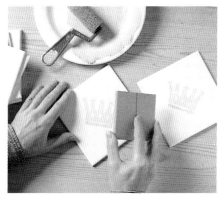

10 Complete the border pattern with a third row of diamonds. Set the fabric paint with a hot iron, according to the manufacturer's instructions.

11 Use dishwashing soap to wash the tiles, and dry them well. Hold the tiles by their edges to avoid finger-prints, which will repel the paint.

12 Spread some gray acrylic enamel paint onto a plate and run the roller through it until it is evenly coated. Ink the crown stamp and print a single crown in the center of each tile on the diagonal.

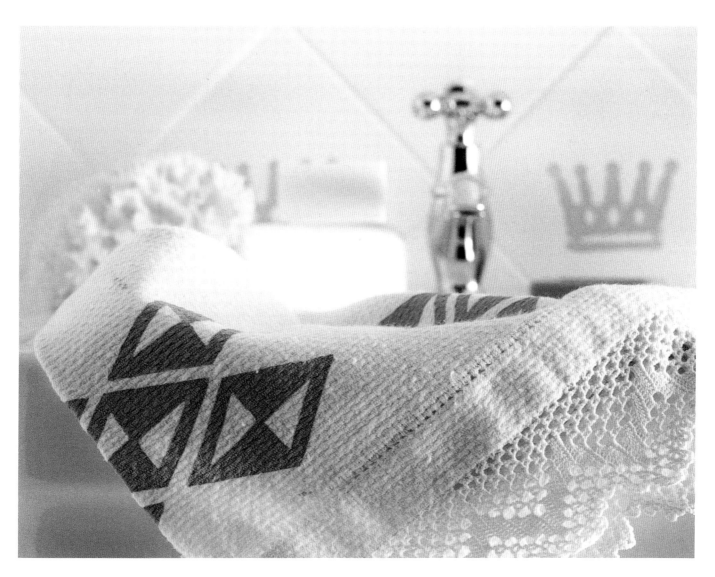

GILDED TRAY

This simple wooden tray is transformed into an item of historic grandeur with an easy gilding technique. Begin by sanding away any old paint or varnish and painting the base of the tray in black and the sides in red-ocher latex paint, applying two or three coats. The heraldic motifs make up a central panel design, and the fine outline is repeated around the edge of the tray. The tray is stamped twice, first with the red-ocher and then with gold size, which is a transparent glue used for gilding. Dutch metal leaf is then applied over the size.

YOU WILL NEED
wooden tray, prepared as above
ruler
pencil
fleur-de-lys and diamond stamps
black stamp pad
scrap paper
scissors
latex paint in black and red-ocher
plates
foam rubber roller
thin wooden stick
lining brush
gold size and Dutch metal leaf
soft and hard paintbrushes
shellac and brush

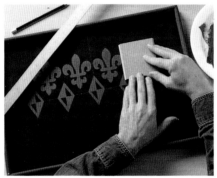

1 Measure out and mark in pencil the six-sided central panel. Draw a border around the edge of the tray. Print eight fleurs-de-lys and five diamonds on paper and cut them out. Use them to plan your design, marking the base point of each motif in pencil on the tray. Spread some red-ocher paint onto a plate and run the roller through it until it is evenly coated. Ink the stamps and print the fleur-de-lys and diamond pattern.

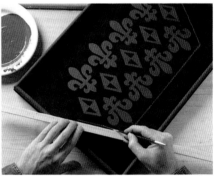

2 Using the stick to support your hand, use the lining brush and the red-ocher latex paint to paint a fine line around the design, following the pencil lines of the central panel. Paint another fine line just inside the edge of the tray. If you have never used a lining brush, practice making lines on scrap paper until you are confident with the technique.

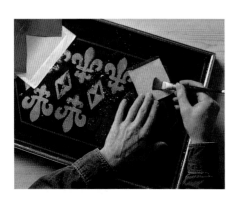

3 Paint the sides of the tray with size. Leave the size to become tacky, according to the time specified by the manufacturer. Place one sheet of Dutch metal leaf onto the size at a time and burnish with the back of a soft brush. Spread the gold size onto a plate and use the roller to ink the stamps with size. Overprint the red-ocher patterns, stamping each print slightly down and to the left of the already printed motif to create a dropped shadow effect. Leave the size to become tacky and gild with Dutch metal leaf in the same way as before. Use a stiff brush to sweep away the excess leaf. Seal the whole tray with a protective coat of shellac.

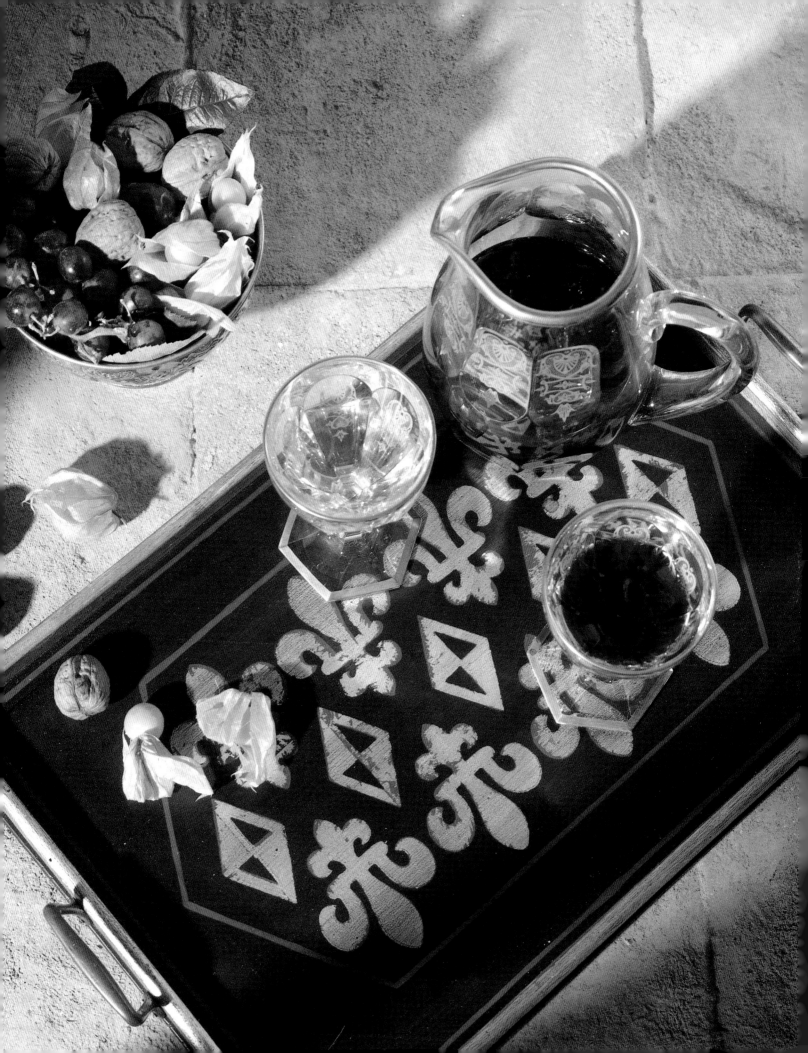

HERALDIC STATIONERY

Design and print a personalized set of stationery to add a touch of elegance to all your correspondence. Heraldic motifs have been used for centuries to decorate letters and secret diaries, but it is no longer necessary to live in a palace to be able to use them. This project demonstrates the variety of ways in which a single stamp can be used to produce different effects. The resulting stationery is based on a common theme but with plenty of individual flourishes. Experiment with your favorite color combinations, and try all-over or border patterns to add even more variety. Many craft stores sell special embossing powders that can be heated to produce a raised print.

YOU WILL NEED
dark blue artist's watercolor paint
plate
foam rubber rollers
diamond, fleur-de-lys and crown stamps
brown packaging paper
craft knife
cutting mat
small notebook, folder, postcards and
textured and plain notepaper
gold paint
dark blue paper
ruler
T-square
white glue
fine artist's brush

1 Spread some dark blue watercolor paint onto a plate and run the roller through it until it is evenly coated. Ink the diamond stamp and print one motif onto a small piece of the brown packaging paper.

2 Cut out the diamond shape with a craft knife on a cutting mat. Try not to overcut the corners because the shape will be used as a stencil and the paint may bleed through.

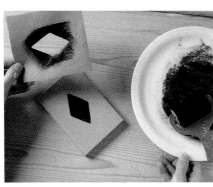

3 Position the paper stencil in the middle of the notebook cover and use the roller to apply blue watercolor paint through it. Allow to dry.

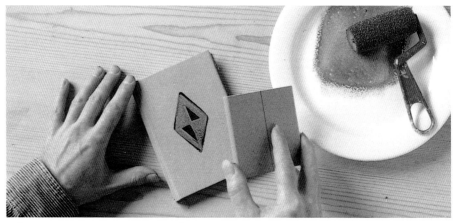

4 Spread some gold paint onto a plate and run the roller through it until it is evenly coated. Ink the diamond stamp and stamp a gold print directly over the solid blue diamond, lining up the edges as closely as possible.

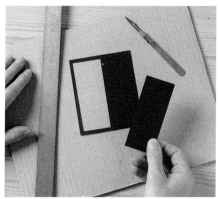

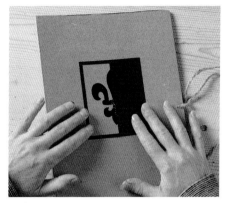

5 Cut a rectangle the size of the fleur-de-lys stamp block out of dark blue paper. Measure and divide it in half lengthways. Cut away one side, with a craft knife, leaving a narrow border around the edge to make a window in one side.

6 Using a ruler and T-square to position the stamp, print a dark blue fleur-de-lys in the center of the folder. Glue the blue paper over the print so that half the fleur-de-lys shows through the window.

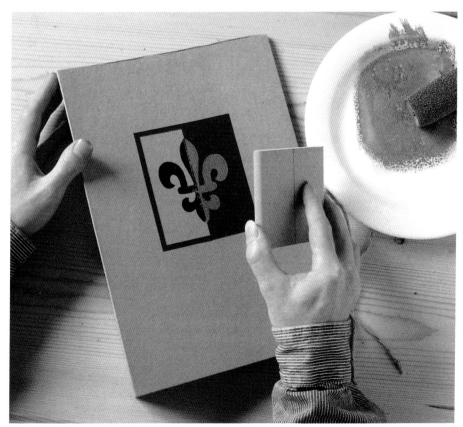

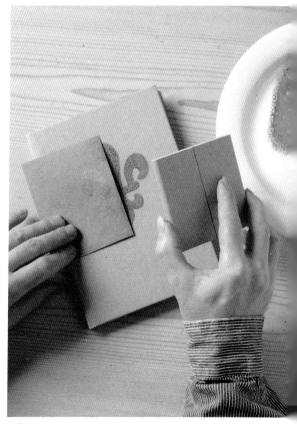

7 Ink the fleur-de-lys stamp with gold paint. Cover the cut-out side of the design with a straight-edged piece of brown packaging paper. Stamp a gold fleur-de-lys to align with the

sides of the blue print. Remove the piece of packaging paper to reveal the final design, which will be half gold and half blue.

8 Stamp a blue fleur-de-lys on a notebook cover or postcard. Cover one half of it with a straight-edged piece of packaging paper and overprint in gold to make a two-color print.

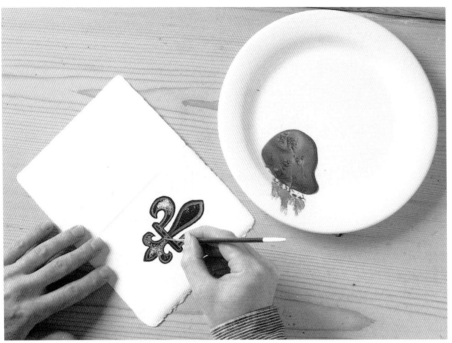

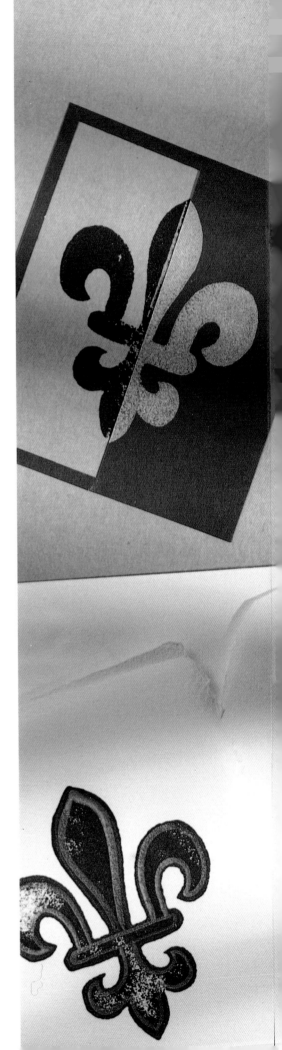

9 Fold a piece of textured notepaper to make a card. Stamp a blue fleur-de-lys on the front of the card. The texture of the paper will show through in places. Add flourishes of gold paint using a fine artist's brush.

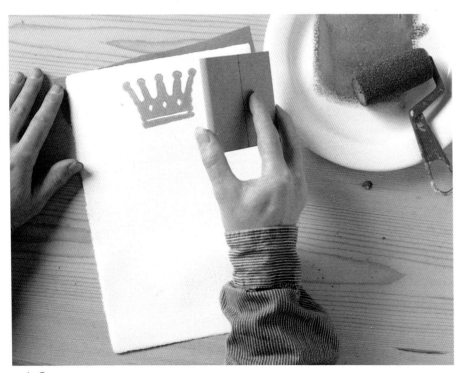

10 Stamp a gold crown at the top of plain white sheets of notepaper.

This edition published in 1996 by Lorenz Books, an imprint of
Anness Publishing Limited
Administration office: 27 West 20th Street, New York, NY 10011

Lorenz Books are available for bulk purchase for sales promotion and premium use. For details write or call
the manager of special sales, Lorenz Books, 27 West 20th Street, New York, NY 10011: (212) 807-6739

ISBN 1 85967 218 3

Publisher: Joanna Lorenz
Senior Editor: Lindsay Porter
Designer: Bobbie Colgate Stone
Photographer: Graham Rae
Stylist: Diana Civil

Printed and bound in Singapore

ACKNOWLEDGEMENTS
The authors and publishers would like to thank Sacha Cohen, Josh George and Sarah Pullin for all their hard work in the studio.